MW00988690

all hail the

birthday

queen

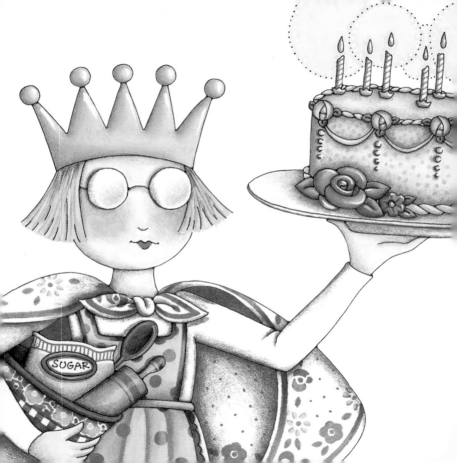

all hail the
birthday
queen

illustrated by mary engelbreit

written by patrick regan

**Andrews McMeel
Publishing**

Kansas City

www.andrewsmcmeel.com
www.maryengelbreit.com

and Mary Engelbreit are registered trademarks of
Mary Engelbreit Enterprises, Inc.

02 03 04 05 06 LEO 10 9 8 7 6 5 4 3 2 1

Design by Stephanie R. Farley and Delsie Chambon

ISBN: 0-7407-2903-9

Long may
birthdays
for you last,
Each one sweeter
than the last!

— M. T. Sheaman

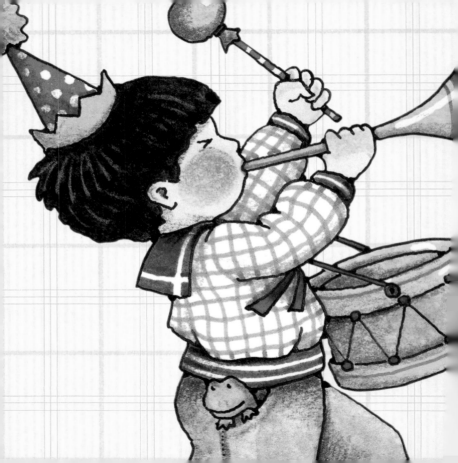

Sound the trumpets!
Strike the band!
Raise a hearty,
 happy cheer!

Set the stage for celebration, 'cause the **birthday** queen is here!

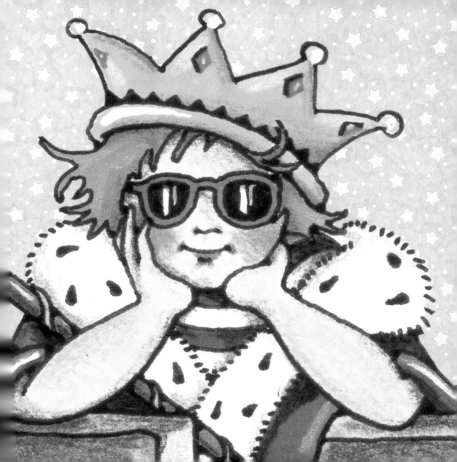

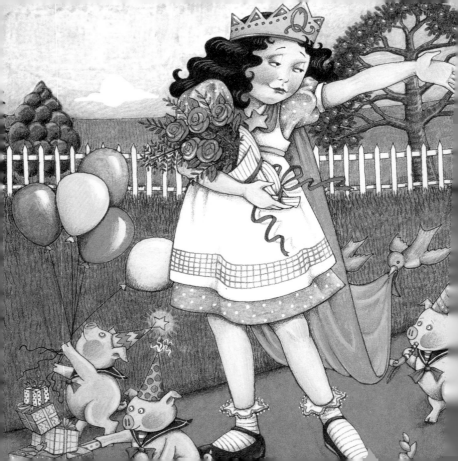

Lay red carpet!
 Throw rose petals!
It's coronation time,

And the crown has
your name on it—
It's for *you* that
those bells chime!

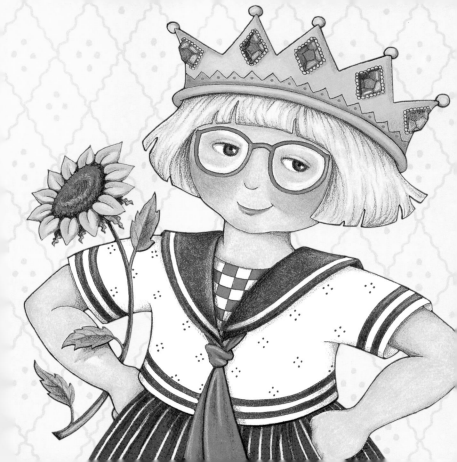

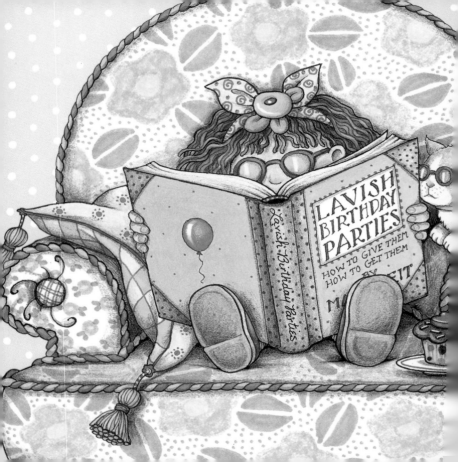

Don't waste time
with work or worry—
There's just too much
to be done.

Your reign won't
last forever—
Make it count
by having fun!

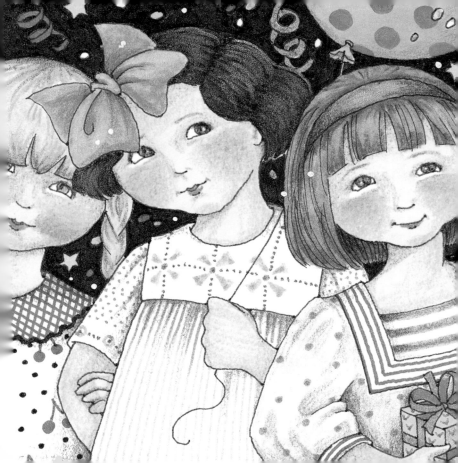

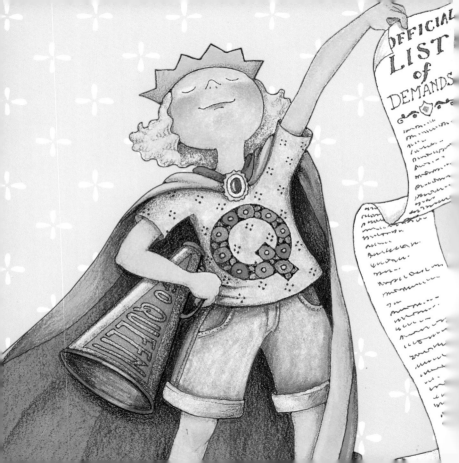

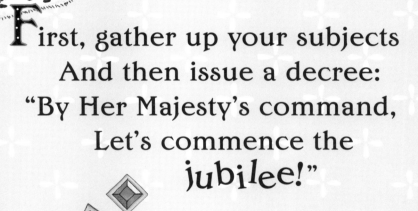

First, gather up your subjects
And then issue a decree:
"By Her Majesty's command,
Let's commence the
jubilee!"

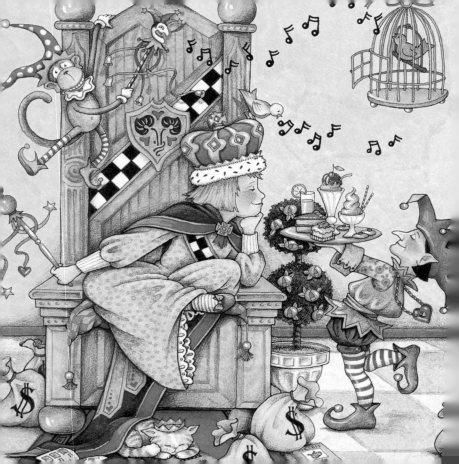

The **birthday**
queen has spoken—
Woe to those
who do not heed.

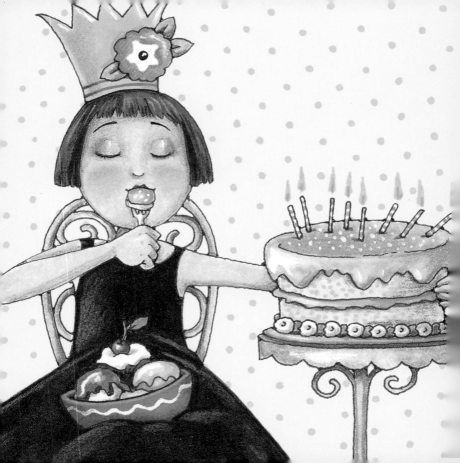

If her royal whims are met,
Merry times are
 guaranteed.

For this Queen's
a rare embodiment
Of beauty, charm
and grace;

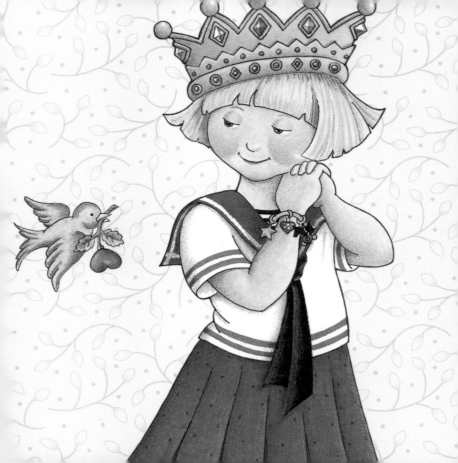

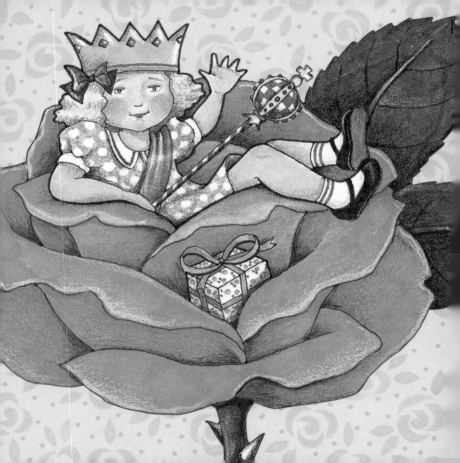

She's a wise,
 good-hearted ruler,
Sharp of mind
 and fair of face.

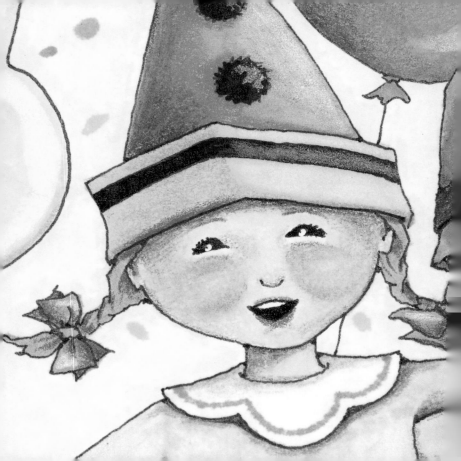

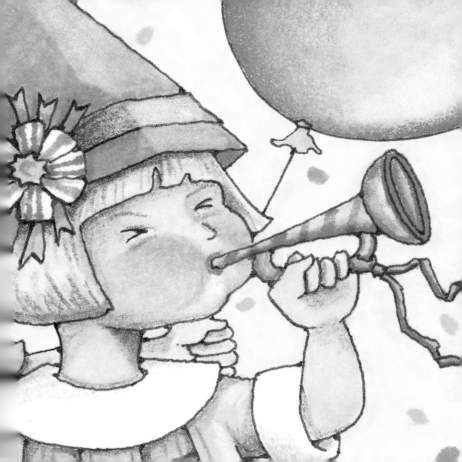

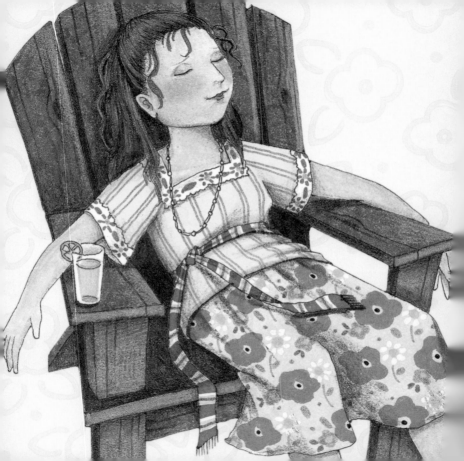

And when the Queen
wants quiet
Let her loyal
subjects hush.

Let them not
 whine or bicker
Or into her
 chambers rush.

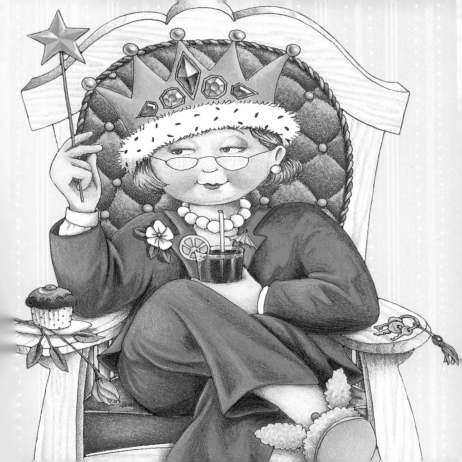

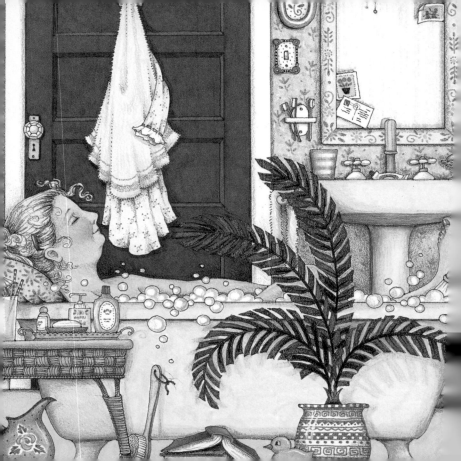

The Queen may want
 a nice long bath
Or a night out
 on the town;

Her every wish
must be fulfilled
On the day she wears
the crown.

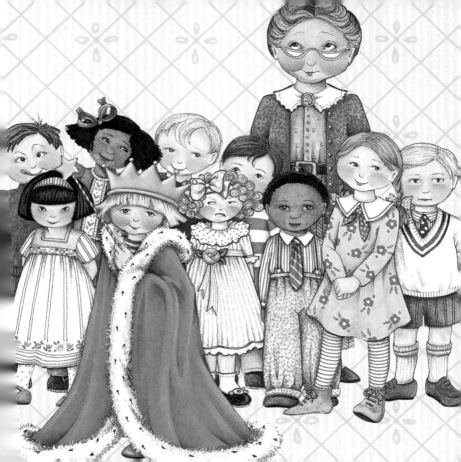

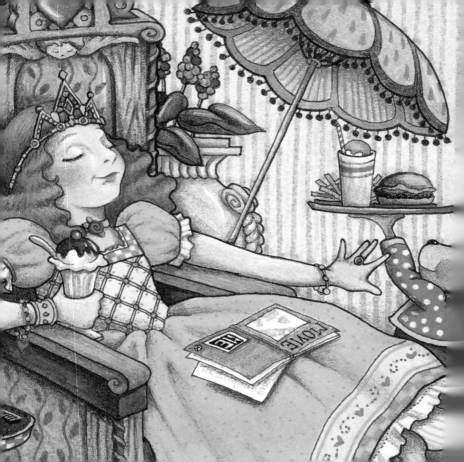

Her eminence deserves a break
From the everyday routine;
So, here's to you,
 most worthy one...

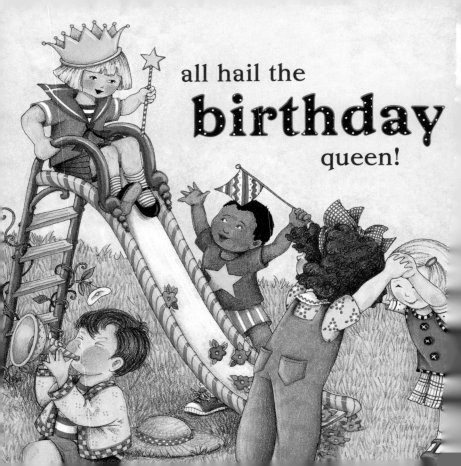

all hail the **birthday** queen!